NEW RULES

NEXT WEEK

NEW RULES

Corita Kent's Legacy through the Eyes of Twenty Artists and Writers

Rules developed by Corita Kent and the students of the Immaculate Heart College Art Department

Essays by Juliette Bellocq, Eric Dever, Lenore N. Dowling, IHM, Jeffrey Gibson, Haven Lin-Kirk, Barbara Loste, Mickey Myers, Dan Paley, Natacha Ramsay-Levi, and Karina Esperanza Yanez

Art by Rebeca Anaya, Gail Anderson, Lisa Congdon, Vashti Harrison, Jen Hewett, Howsem Huang, Erin Jang, Amos Paul Kennedy Jr., MacFadden & Thorpe, and Carissa Potter

Introduction by the Corita Art Center

CHRONICLE BOOKS
SAN FRANCISCO

Library of Congress Cataloging-in-Publication Data:
Names: Bellocq, Juliette, contributor.
Title: New rules next week : Corita Kent's legacy through the eyes of twenty
 artists and writers / rules developed by Corita Kent and the Immaculate Heart
 College Art Department ; essays by Juliette Bellocq, Eric Dever, Lenore N.
 Dowling, Jeffrey Gibson, Haven Lin-Kirk, Barbara Loste, Mickey Myers, Dan
 Paley, Natacha Ramsay-Levi, and Karina Esperanza Yanez ; art by Rebeca
 Anaya, Gail Anderson, Lisa Congdon, Vashti Harrison, Jen Hewett, Howsem
 Huang, Erin Jang, Amos Paul Kennedy Jr., MacFadden & Thorpe, and Carissa
 Potter ; introduction by the Corita Art Center.
Description: San Francisco : Chronicle Books, [2023]
Identifiers: LCCN 2022047156 | ISBN 9781797211824 (hardcover)
Subjects: LCSH: Corita, 1918-1986--Philosophy. | Immaculate Heart College
 (Los Angeles, Calif.)--Regulations. | Maxims, American.
Classification: LCC NE2237.5.K4 N49 2023 | DDC 764/.8092--dc23/
 eng/20221019
LC record available at https://lccn.loc.gov/2022047156

Manufactured in China.

Cover lettering by David Mekelburg.
Design by Kristen Hewitt.

10 9 8 7 6 5 4 3 2 1

Chronicle books and gifts are available at special quantity discounts to corpo-
rations, professional associations, literacy programs, and other organizations.
For details and discount information, please contact our premiums department at
corporatesales@chroniclebooks.com or at 1-800-759-0190.

Chronicle Books LLC
680 Second Street
San Francisco, California 94107
www.chroniclebooks.com

Contents

Introduction

I t is a pleasure to introduce such a visionary document as the Immaculate Heart College Art Department Rules. Though the Rules have been cherished and widely circulated, their origin and contemporary applications have never been thoroughly explored. We have faith that this book will serve as a foundation for many more conversations ahead.

In Baylis Glascock's prescient documentary film from 1967, *We Have No Art*, a habited Corita sits with a group of Immaculate Heart College Art Department students in the basement classroom. This teaching space was a common gathering point for classes, film watching, guest lectures, and art displays. Corita asks, "What kinds of general things would any of you have in mind if you were writing ten principles for a teacher making assignments?" One student quickly chimes in, "Have a heart," and a chuckle rolls through the group of young students who recognize this as a reference to Corita's abundant homework assignments, such as "Do one hundred drawings by tomorrow, using your nondominant hand."

This tactic was not about creating busy work, nor was it strictly for honing technical skills. For Corita, the imperative of a teacher was to provide a supportive structure that empowered students to make choices and arrive at new ideas. As an educator, Corita challenged the "standard" hierarchy of knowledge that was often assumed in a conventional academic environment. By placing the student in the driver's seat, she honored the student by not assuming that they entered the classroom bare of knowledge. Quite the opposite. Each student, she believed, was brimming with their own perspective on the world, often formed by lived experiences that they could, in turn, question and reposition. These ten principles capture a conversation between an educator and her students, a collaborative agreement around what a learning environment hopes to imbue.

In the decades since its conversational creation, this perennial list has gone on to lovingly hang in classrooms, studios, and homes of individuals and

communities as they explore their creative pursuits. Corita Art Center is so honored and fortunate to collect the many heartfelt stories of those who were inspired by or knew Corita. This book is a small sampling of these conversations.

About the Title

At the very bottom of the list of ten rules are Helpful Hints. Among them is "There should be new rules next week," which offers freedom to the reader to go forth in their pursuits. It's a wink and a nod that reminds us that rules are not ironclad, that life can be joyously unpredictable, and that one should always remain open to new ideas. We hope that this compilation of stories and artwork encourages the next generation of doers and makers to create new rules.

About Corita Kent

Corita Kent was an artist, educator, and advocate for social justice who worked primarily in serigraphy. Born Frances Elizabeth Kent on November 20, 1918, in Iowa, Corita was raised mainly in Los Angeles. She entered the religious order Immaculate Heart of Mary in Hollywood at age 18. After teaching secondary school in Los Angeles and then briefly in the Pacific Northwest, Corita was called back to teach art at Immaculate Heart College. Under the direction of Corita and Sister Magdalen Mary, the art department became a well-known center of creativity and liberal thinking with a recognizable aesthetic style. In the early 1950s, Corita began printmaking. Influenced by the medieval art she was studying while obtaining her master's degree at the University of Southern California, her early work was figurative and religious.

Until 1967, Corita produced prints in the college studio during her breaks between teaching summer school and the start of the fall semester, averaging 20 different prints in editions ranging from 25 to 200. During that time, her work incorporated advertising images and slogans, popular song lyrics, biblical verses, and literature. Her vibrant and socially conscious artwork became enormously popular. By 1968, she had shown in over 230 exhibitions, and her

work was collected in public and private collections worldwide. Throughout the 1960s, her work became increasingly political, urging viewers to consider poverty, racism, and injustice. Always resistant to the division between fine and commercial work, Corita took commissions large and small during her career, from greeting cards to book jackets and illustrations, posters, billboards, and even a US postage stamp.

In 1968, exhausted from conflict with the Los Angeles archdiocese and a frenetic schedule of exhibiting, teaching, and lecturing around the country, Corita sought dispensation from her vows and moved to Boston. She continued to work in serigraphy and developed a plein air watercolor practice. After 1970, Corita's work evolved into a sparser, more introspective style influenced by her new environment, secular life, and battles with cancer. She remained active in social causes until her death in 1986. At the time of her death, she had created nearly 800 serigraph editions, hundreds of watercolors, and numerous public and private commissions.

Corita bequeathed her copyrights and unsold art to the Immaculate Heart Community (IHC). Recognizing the continuing relevance and importance of her art and teaching, IHC created the Corita Art Center to keep her legacy alive for generations to come. With thousands of original serigraphs, watercolors, and archival materials, the Corita Art Center is the largest and most comprehensive archive of Corita's work. Learn more about Corita Art Center and Corita Kent by visiting corita.org or following @coritaartcenter.

Rule 1:
Find a place
you trust
and then
try trusting it
for a while.

Words by Natacha Ramsay-Levi

Art by Lisa Congdon

I was introduced to Corita Kent's work by a friend, Ligia Dias, a jewelry designer and artist. I immediately fell in love with Corita's work, for its formal aspect, of course, but also for what her work says about commitment, generosity, and the strength of demonstration. And then the rigor, the tenacity, of using mainly one medium: silk-screen printing. This medium has allowed her work to go beyond and melt the borders of art and graphic design, of aesthetics and politics, to achieve works that are immediately accessible, works that everyone can understand and appropriate.

For me, as an artistic director in the fashion industry, there are essential questions embedded in Corita's practice. This ability of a designer to express a clear commitment, immediately impactful, through a very generic medium—silk screening and demonstrating for Corita, clothes and catwalks for me. This way of using codes known to all—advertising or clothing—and diverting them to make possible a certain way of being, to invent a moral identity in connection with contemporary societal issues.

In the dialogue between the objective world and the subjective self, which every creative person is continuously aware of, Corita's ten rules propose a method towards a personal way. And when I was offered the opportunity to write an essay on one of Corita's rules, I naturally—or unnaturally?—chose the first one: Find a place you trust and try trusting it for a while.

As always in Corita's work, this rule seems to be as relevant as ever.

There are a number of things that strike me here, beginning with the tone with which Corita addresses her students. Through a subtle mixture of assertion—since it is a rule—and of soft incitement—since it is about trying—we discern a feminine voice in which things remain open, tolerant. A voice that holds its strength in its flexibility.

This voice also insists on the confidence that any artist must find, if not for their work, at least for their mental health, in order to oppose the alienation, or the paralysis, caused by their own internal criticism as well as the gaze of others.

Corita's call to trust, to stability, to presence, pushes us to defy the dispersion and the increasing over-solicitation of our current society. In a world

where competition is always exacerbated and evaluations are ubiquitous, we sometimes need to spend more time on something toward which our heart is inclined. Trusting our work and our creative process helps us to rise to another level. With that trust, I can take part in human interactions or world affairs, and I achieve this through my focus on my place, on that stability that I strive to hold.

This stability that Corita encourages us to find is initiated by motion—"find a place"— which must open a way for us. The movement can be physical or an inner movement of consciousness. Rule 1 in particular is a call to a concrete realization of individuation. Yves Citton writes, "Attention allows us to ensure a certain form of existence by making a certain form of new and unique life emerge in us; but above all, it allows us to acquire a greater 'consistency' within the relationships that are woven within us. Far from helping us only to persevere in being, it allows us to become ourselves."[1]

We always talk about a lack of attention or an excess of attention, but what Corita proposes here is to fix attention. Attention gives me the necessary confidence to speak; it allows me to organize my incessant interactions with the world, to escape the chaos of a random ballot. Attention allows me to remain for a while in a place I've found, despite my own internal criticism and the noises of the world.

Corita's incitement to conduct our attention in an intentional and thoughtful way resonates as a resistance to hyperactivity, to the flood of images and information and the overwhelming over-occupation that today's world can engender. As an artist, I must fix my attention for a time.

By doing so, I can try to understand what to do with my attention. I can learn that from this attention will emerge a certain production of the self. In *Waiting for God*, Simone Weil writes, "Never, in any case, is any genuine effort of attention ever lost; . . . whenever a human being makes an effort of attention with the sole desire of becoming more capable of grasping the truth, he acquires this greater aptitude, even if his effort has produced no visible fruit."[2]

The effort of attention bears its fruit in the increase of our ability to pay attention—which appears from then on as a good in itself.

[1] *Pour une écologie de l'attention*, Points, 2021.

[2] *De l'attention - Réflexions sur le bon usage des études scolaires en vue de l'amour de Dieu*, Omnia, 2018.

Through attention,
I gain my freedom,
my emancipation,
and my power to act.

In addition, by opening spaces of reflection, I pass from an undergone individuation to an oriented individuation. I can build the consistency of my personality gradually and without end. It is through this effort that I can direct my gaze, my listening, and my hand, and that I can filter the flow of information that I consider or decide to consider.

Through attention, I gain my freedom, my emancipation, and my power to act. Attention determines what I will be tomorrow by allowing me to choose what I see and hear today. If it is true that we are what we eat, then we are what we watch and listen to.

But with the phrase "for a while," Corita reminds us that nothing is permanent, that neither this quest nor this attention ever remains static. The nature of attention is "not to hold in place."[3] Attention is an exceptional, abnormal state, which cannot last long because it is in contradiction with the fundamental condition of psychic life: change. Cathy N. Davidson praises the merits of continuous partial attention: "In our global, diverse, interactive world, where everything seems to have a hidden side, continuous partial attention could well be not only a condition of life, but also a precious instrument for navigating this complex world. This will be all the more true if we manage to compensate for our own partial attention by collaborating with others who can see what we are missing. Only then can we increase our chances of success and hope to see the hidden side of things—as well as the hidden side of that hidden side itself."[4]

The creative process involves a lot of spontaneity, and I believe that with her first rule, Corita encourages us to temporarily fix our attention, in order to find the right place between lamenting information overload and marveling at the experience of curiosity.

[3] Jean Philippe Lachaux, *Le cerveau attentif*, Odile Jacob, 2013.

[4] *Now You See It*, Penguin Books, 2012.

RULE #1 ►►►►►►

FIND A PLACE YOU TRUST AND THEN TRY TRUSTING IT FOR AWHILE

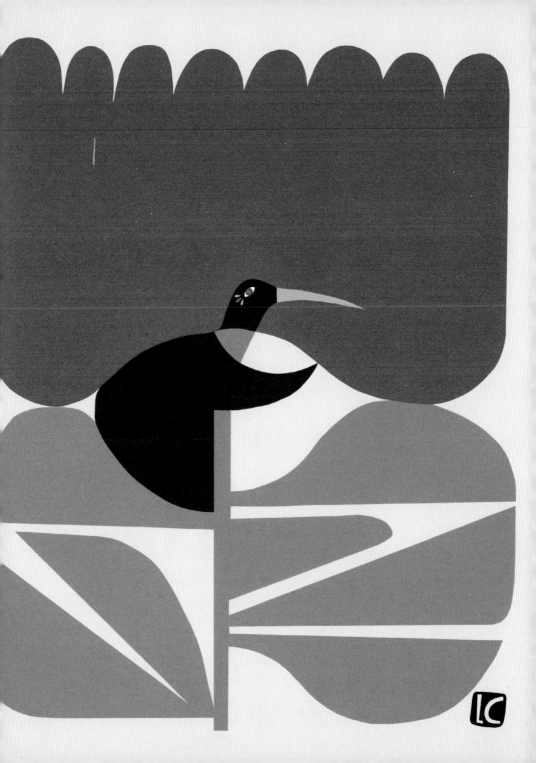

Rule 2:
General duties of a student:
Pull everything out of your teacher. Pull everything out of your fellow students.

Words by Barbara Loste

Art by Howsem Huang

Okay, so you followed Rule 1. Great! You found a place you trusted and tried trusting it for a while. Well done. Now it's time for Rule 2: "General duties of a student: Pull everything out of your teacher. Pull everything out of your fellow students." It's a major ask.

As luck would have it, when Corita and her students first came up with the ten Immaculate Heart College Art Department Rules, I was in the room where (and when) it happened. Without knowing it, we were making magic that day. Corita was stunningly convincing, and we were all a bit stunned. Documentary filmmaker Baylis Glascock captured the moment in *Ten Rules for Students and Teachers: Corita on Teaching and Celebration*, in which her teaching, her students, and her art are shown as inseparable.

In the 1960s, Corita had a relentless schedule. She was chair of the college art department; she taught art theory and practice; she carved out time during academic recesses to make her own serigraph prints; and she was active within her religious community. Simultaneously, her pioneering teaching methodology was becoming legendary. Years later, in *Learning by Heart: Teachings to Free the Creative Spirit* (2008), Corita and coauthor Jan Steward would provide a step-by-step manual for art teachers, or for "anyone who ever wished they could draw, paint, or make things . . . or had hopes of changing something for the better." Unsurprisingly, many of Corita's students idolized her. We wanted to be her. We imitated her calligraphy, we tried to live up to her demanding work ethic, and we were deeply influenced by how she connected the arts, high and low, with what she called the stuff of everyday life. "There's nothing wrong with the ordinary," she notably quipped, "there's simply lots of it."

Corita understood that as students we had to unlearn much of what we thought we knew. In order to jolt us out of timeworn ways of seeing and making, Corita assigned seemingly impossible tasks: bring in one hundred original drawings by Friday; over the weekend, carve two alphabets out of rubber erasers; practice drawing with your eyes closed for as long as you can; write out five wonderful quotes using chopsticks dipped in black India ink; concentrate on the spaces around objects rather than on the objects themselves to discover new meanings within the blanks. Corita famously had us make "finders" by cutting rectangles in scraps of heavy paper. She

coached us on using the finders for "slow looking," focusing on a portion of a whole without being overly distracted by content.

Long before the popularity of podcasts, we paid close attention to cultural innovators. Campus visitors included futurist/architect Buckminster Fuller, activist priest Daniel Berrigan, and pacifist author Jim Forest. We also watched intriguing film loops starring soapsuds, cracks in the sidewalk, toys, and carousels, screened for us by visionary designers Ray and Charles Eames. Following the rules, we pulled everything out of each experience, delighted (and sometimes overwhelmed) by so much serious play.

As learners, we also took to heart the idea of "pulling everything out of our fellow students" in the form of student projects that met the demands of some of Corita's numerous commissions. In 1966, under the leadership of two fourth-year students, we prepared a Christmas exhibition for the display windows at IBM's headquarters in Manhattan. In a time of anti-war sentiment, the work was aptly titled *Peace on Earth*. The show consisted of 725 stacked, hand-lettered, photocollaged packing boxes calling for a moment of reflection and hope. *Survival with Style*, another student-led project, followed in 1967. This installation consisted of 1,500 vividly painted cardboard boxes displayed during a conference on religion and the arts in New York. The maze of colorful, disposable towers invited viewers to imagine alternatives to war, poverty, and hunger.

In both her teaching and her art, Corita was a committed storyteller. She blended words and visuals into cultural tapestries, linking fragments from billboards, poetry, prayers, advertising, and song lyrics into what became signature, boundary-pushing remixes. In an iconic 1967 print, *for emergency use soft shoulder*, Corita eagerly scrawls, "powerful enough to make a difference," a publicity claim she juxtaposes with a bold blue-and-red instruction, "get with the action." As Ghanaian friend Amowi Sutherland Phillips—who during many conversations with me came to know and admire Corita—summarized, "In West African oral traditions, a *griot* is a storyteller, a keeper of culture. Well, it sounds to me like Corita was truly a griot!"

Years before googling and scrolling became verbs, Corita peppered her classroom lectures with stirring quotes from sources as diverse as Walt Whitman,

Corita understood
that as students
we had to unlearn
much of what we
thought we knew.

e.e. cummings, Mahatma Gandhi, the Beatles, Dr. Martin Luther King Jr., and Cesar Chavez. Her research, fueled by her insatiable curiosity and chronic insomnia, became an open invitation to pause, reflect, interconnect, and see art-making as important and socially valuable. Five decades after the rules were first conceived, they remain a timely guide. With huge amounts of data at our fingertips today, we can try—perhaps more readily than ever—to pull everything out of our teachers, our mentors, and each other. It's still a big ask. The good news? As Corita reminded us, there will be new rules next week.

< As the word "pull" suggests, this design is composed of elements created by the methods I learned from my classmates, professor, and other artists in college. They are monuments standing on my learning and career path.

Rule 3:
General duties
of a teacher:
Pull everything out
of your students.

Words by Lenore N. Dowling, IHM

Art by MacFadden & Thorpe

As teachers, we are enriched by listening and by asking questions that invite students to be creative in their thinking, writing, and projects. For example, one class presented a TV broadcast for their final presentation to integrate their studies in a visual medium. Students have imaginations that we sometimes need to "pull out" by coaching and encouraging their curiosity and invention. Thus, when students have a creative teacher who listens, who isn't prescriptive but spontaneous, who recognizes the possibility of expanding what students bring to the class, and who generates excitement about the gifts students discover in themselves and in one another—learning in a community like this is its own reward.

As teachers, we have a wonderful opportunity to explore with students how they can enrich their lives with poetry, for example. When I taught at Immaculate Heart High School, my students wrote poetry and made poetry books. To this day, I hear from former students about how that introduction to poetry has continued to enrich their lives. And some have published articles, novels, and poetry.

At Immaculate Heart College, I was a colleague of Corita's in the art department and learned from her how assignments that are disciplined, yet playful, can generate new expressions of thought and feelings. I taught film classes, and students created images that reflected the times: the civil rights movement, the Vietnam War, and women's rights.

Students arrive in class with gifts to share, which some have already discovered and others begin to discover. All learn to share with one another and grow together. When students find that their gifts are valued, they are set free to invent, to imagine, and to contribute to the group. There's an inward growth of confidence and self-assurance, and an outward growth of helping others to share their gifts—their inspirations, dreams, and talents. Together, they become a community of eager, enthusiastic explorers and searchers, bound by the joy of a shared journey and hope.

To "pull everything out of your students" challenges teachers to be good listeners and skillful guides on the paths of learning that students are invited to explore and develop in the classroom, for the time being, and for a lifetime.

I was a colleague
of Corita's in the
art department and
learned from her
how assignments
that are disciplined,
yet playful,
can generate new
expressions of
thought and feelings.

General

EVE
THI
OUT OF
STUD

duties of a teacher:

EVERYTHING YOUR PARENTS

Rule 4:
Consider everything
an experiment.

Words by Haven Lin-Kirk

Art by Erin Jang

A rtists and designers meander in their creative process. I see it when working with my students, and I recognize it in my studio practice. This process typically begins with more questions than solutions, whether you're tackling a new technique or perfecting an established skill. Often, one action or idea is followed by endless possibilities for what else may develop. My exploring involves long lists of materials to use, vantage points to consider, and narratives that ignite further options for future designs. One of the beautiful discoveries of a vibrant studio practice is realizing there's never enough time, space, or effort to complete all of our ideas, and realizing how rich our internal world can be. I find creativity often follows curiosity. Creative experimentation promotes divergent thinking that leads to multiple answers and solutions. The quest to capture an idea becomes as essential as the finished outcome and allows us to see the world in new ways.

The road to creativity and inspiration always includes "try." Corita's decalogue for learning to live creatively also acts as a list of principles for how to see the world fully and honestly. Rule 4 speaks to the existence of different outcomes and exploration. The invitation to explore opens up possibilities to embrace imperfection and randomness, and the act of experimenting suggests discipline and commitment to a practice.

This rule, when considered and applied to creative practice, expands ideas. More importantly, and not *just* when we are wearing our artist's label, adopting experimentation allows us to bring fresh eyes to everything we explore. Corita challenged her students and herself in pursuing new techniques and means to create work. She often stressed the idea that experimenting can cast a new light on mundane activities, such as a routine walk home. Approaching this as a mindset nurtures different views of the world. Rule 4 speaks of an adventure, if we consider the world through a different lens, such as by using other senses or identifying details that we don't usually register. A walk home focusing on smell or touch brings another level of consciousness to the activity. With a deliberate decision to change our perspective, the mundane act becomes an adventure and ignites the imagination.

Experimenting lies at the core of most artists' and creatives' practices. Creativity assumes that an act or activity is unique, but experiments allow

for and even encourage repeating and testing until a final result is achieved. These acts might produce similar results, or something completely different, and how the individual repeats the process can bring about incredible results. By applying rigor and dedication to *everything*—repeating, testing, and finally committing oneself to an idea—unique discoveries can be made.

Corita's work repeatedly explored concepts and techniques, such as using different color combinations in layout or reversing, rotating, or distorting the found text. Her dedication to exploring and experimenting made her a magnet for others, whether her students or the artists and designers who gravitated to her. The process of experimenting was as critical as the final completed work. It speaks to the love of a studio practice and immersing oneself in the production. Kent's dedication to her studio practice is well documented. She printed late into the evening, producing stacks of prints with multiple layout iterations, providing evidence of the various trials and errors she explored as part of her experiments.

The impact of Corita's art allowed her to communicate her convictions about social justice, her spiritual beliefs, and the thoughts of her time in combination with advertising, found imagery, lyrics, and literary quotes. Corita Kent's legacy would not have been possible without a lifetime of exploration.

Rule no. 4

CONSIDER
EVERYTHING
AN

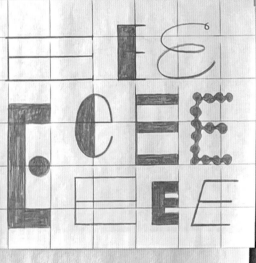

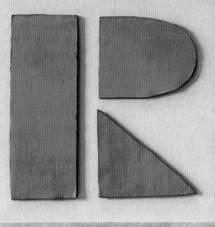

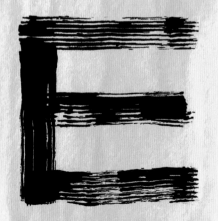

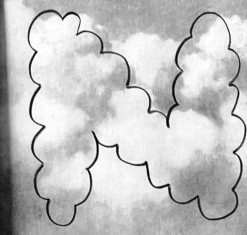

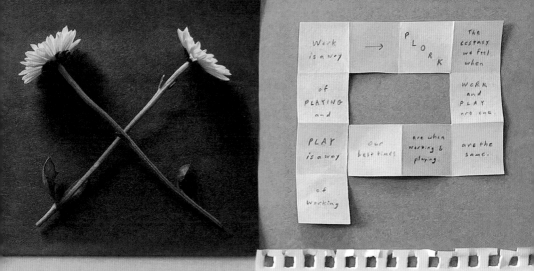

Work is a way → P L O R K | The ecstasy we feel when

of PLAYING and | WORK and PLAY are one.

PLAY is a way | Our best times | are when working & playing | are the same.

of working

Almost anything can be a stamp. Take something in nature — two dandelions — and look at them closely... no two things are the same. Everything is one of a kind. Make a folding book. These books offer surprises in the way they move back and forth, revealing small sections, combinations of unrelated materials, or the whole contents at once. Put something, anything, on paper and then do it over and over. The most important thing is to play. Don't search too hard for materials. Use what you have — your hand, a fork, a leaf, a newspaper, glasses, a rubber stamp, a postage stamp, a soup can, a penny, a piece of fruit.
 Be an inventor and find your own tools and techniques. Watch the clouds... let them get inside you and take form in your pictures. Let a child give you beginning lessons in looking.

< *Almost anything can be a stamp. Take something in nature—two dandelions—and look at them closely . . . no two things are the same. Everything is one of a kind. Make a folding book. These books offer surprises in the way they move back and forth, revealing small sections, combinations of unrelated materials, or the whole contents at once. Put something, anything, on paper and then do it over and over. The most important thing is to play. Don't search too hard for materials. Use what you have—your hand, a fork, a leaf, a newspaper, glasses, a rubber stamp, a postage stamp, a soup can, a penny, a piece of fruit. Be an inventor and find your own tools and techniques. Watch the clouds . . . let them get inside you and take form in your pictures. Let a child give you beginning lessons in looking.*

The text featured on the previous spread comes directly from one of my favorite books by Corita Kent, *Learning by Heart*. This treasure of a book is filled with Corita's ideas and prompts that encourage exercising creativity in the everyday. I selected some of her instructions to guide my experimentation in creating each of these letters (making a stamp, folding an accordion book, observing and collecting from my walks around the city, shedding perfectionism through repeated marks, playing with unlikely tools like pennies or a toothbrush, and watching a child create).

Rule 5:
Be self disciplined.
This means finding
someone wise or smart
and choosing to follow
them. To be disciplined
is to follow in a good way.
To be self disciplined is to
follow in a better way.

Words by Dan Paley

Art by Gail Anderson

I was introduced to Corita's art in the home of Ben Loiz, an Los Angeles–based designer and a mentor to me in creative work. Over lunch, I asked about a piece that hung on his wall. "That one is by Corita Kent," he told me. "Who's Corita Kent?" I replied. He went on to say that he had had the same question years earlier—a friend had told him his work resembled Corita's, and yet he had never heard of her. *How could that be?* I wondered.

The idea that artists influence artists is not new. Some artists actively model their heroes. Some are inspired organically by those whose work they consume. But others, it seems, are influenced unconsciously by artists they've never heard of, artists who leave marks on entire fields even though the attribution gets lost. For Ben and many others, this has been the case with Corita. Her role in both the pop art movement and in applying the aspirations of the Second Vatican Council are not yet fully appreciated. As Harvard art historian Susan Dackerman notes, "Although she participated in two heady cultural undertakings—the reformation of religion and art—during the 1960s, she was an outlier in both movements, seemingly, and paradoxically, because of her association with the other."[1]

We seem to compartmentalize people and only acknowledge meaningful contributions from those who specialize in specific disciplines—painters paint, writers write, reformers reform. But what happens when musicians draw or writers sing or, in the case of Corita, a Catholic nun teaches and takes pictures and makes prints? What do we do with them? What is their discipline?

Was Corita aware that hers would be an interdisciplinary legacy? I suspect so—even in her day, the attention she received from *Newsweek* and other outlets focused on her being a nun-artist or an artist-nun. Did she care? Clearly not—she taught faithfully and snapped photos and produced serigraphy and delivered commissioned work at a pace that would have been impressive even for specialists in any one of those disciplines. Perhaps we struggle with interdisciplinary artists. Or perhaps, in the case of Corita, we have misunderstood what her discipline was. What if it wasn't art or teaching or religious service? What if her discipline was *love*?

Okay, what does any of this have to do with Rule 5? Among the ten rules, it's the only one accompanied by a definition and, at that, a definition that

[1] Susan Dackerman et al. *Corita Kent and the Language of Pop*, ed. Susan Dackerman, Harvard Art Museums, distr. Yale University Press, 2015.

seems unrelated. If the rule were simply "Be self-disciplined" we would receive it as a rule being about, well, following rules, working hard, sacrificing, and subjecting oneself to training and regimented strictness. After all, when a 1950s-era nun has a rule about discipline, we sit up straight. But what does discipline have to do with "finding someone wise or smart and choosing to follow them?"

It's important to note whom and what Corita chose to follow. First and foremost, she followed a path into religious service. As someone who spent many years on a similar path, I can say that such choices are rooted not in rules and regulations, but in love. The scripture that Corita read and incorporated into her art says that the God she followed is love itself, that abiding in love equals abiding in God, and that God's followers ought to love one another. Corita took this to heart. She also chose to follow her schoolteachers and, later, her fellow sisters at Immaculate Heart. She chose to follow political leaders like John F. Kennedy and civil rights leaders like Martin Luther King Jr. She chose to follow poets like e. e. cummings and designers like Charles and Ray Eames, activists like Mahatma Gandhi and thinkers like Albert Camus. Corita, whose name means "little heart," chose love as her discipline, and she chose to follow the sort of people who could teach her how to practice it.

I began to follow Corita at a time when my love had run dry. As a result, I rediscovered discipline in both senses of the word. Her heart of love imbued my writing with deeper purpose—discipline as in "field." Her method of hard work energized my creative effort—discipline as in "diligence." She was right that creative people do well to find someone wise or smart and choose to follow them. Those people are often around us as teachers and mentors. Sometimes they're far off in space or time, like Corita was for me.

When I work with writers, elementary school students and college professors alike tell me the same thing after we read a book or article together: "I could never write that." And you know what? They're right. In fact, even the person who wrote the thing we're reading couldn't write it in its final form. The first few drafts were likely no good. (The editor of this collection is thinking of my first draft and nodding knowingly.) But most of us only see the finished product and are paralyzed by the enormous gap between it and our work at its start.

What if her
discipline was *love*?

Following a mentor or teacher opens a window into the painful process of creative work and shows how incremental and bad it often is. Corita's students chose to follow her even when she assigned hundreds of drawings for homework. These assignments pushed them through the process to teach them discipline and, if they wanted to complete the drawings, to resist perfection—something with the power to halt production altogether. Corita called them to reach, beyond their toil, to a greater discipline.

Corita's discipline was love for the world and she disciplined herself to express it through art. "Work," the Lebanese poet Kahlil Gibran wrote in his profound poem "On Work," "is love made visible."[2] Much like her serigraphs, layered with vibrant colors and thought-provoking text, Corita's life and art were, in the end, not interdisciplinary but inseparable, conveying a heart of love made visible through art.

To be disciplined is to follow in a good way—developing the craft and work ethic required to create. To be self-disciplined is to follow in a better way—finding the greater purpose that animates an artist to endure the hard work of creating. What's your discipline?

[2] Kahlil Gibran. *The Prophet*, New York: Knopf, 1923.

RULE 5 ▸▸▸▸▸▸ BE SELF-DISCIPLINED.

THIS MEANS FINDING SOMEONE WISE OR SMART AND CHOOSING TO FOLLOW THEM. TO BE DISCIPLINED IS TO FOLLOW IN A GOOD WAY. TO BE SELF DISCIPLINED IS TO FOLLOW « IN A BETTER WAY. »

Rule 6:
Nothing is a mistake.
There's no win and no fail.
There's only make.

Words by Juliette Bellocq

Art by Amos Paul Kennedy Jr.

So much happens in a millisecond. As I get ready to start a project, my thoughts run to Corita and there it is already, the encouraging voice. *Nothing is a mistake. There's no win and no fail. There's only make.* I hear her go straight to the intimate, vulnerable part in us makers, to soothe our fears. Yes, she knows about the difficulty of the creative process. She knows about the other voice, the insidious one that relentlessly whispers, *Are you sure this is going anywhere?* before we have even finished a thought. With her *Nothing, No, No, Only,* she beats that one to the punch and counters it before it starts its sabotage.

Her words may sound sweet, and the environment she creates for us even safe, but I cannot help noticing a much bigger impetus. See, she is a teacher, and she wants results. When nothing is a mistake, we can assume there will be no waste. All is needed. If there is no win and no fail, there will be no judgment and therefore no interruption. No one will declare an end to the process for "medal time," no one will throw us out of the game. Goodbye separateness, isolation, inadequacy. So long, shame. Great riddance. But that also means we are powering through for the long run. In three short sentences, Corita clears out the field and removes all stop signs: We are going to explore all directions! All needs to be considered! What an amazing way to say: Everything is okay, yet it is bigger than you think

This brilliant little rule stands as the most concise how-to manual on how to create in difficult times. The difficulty might be the dread of the blank page, or it might be much deeper than that. In this very minute, when racism, sexism, and bigotry dominate the news cycle, how paralyzing it is to create anything. How terrifying to make while wars are declared and fought, while injustice seems to prevail, while the future of the ecosystem we are part of is uncertain at best. We sure face this reality, but so did Corita.

She might dazzle us with her colors and celebrations on a page, her hopes posted high and her typographic humor. She makes it look easy to rally communities and engage in action. All these joyous threads, however, stem from the dark place from which she had to create.

Corita's teaching career—the period during which she created most of her work—was bookended by social change and injustice. She started teaching in 1951, in the aftermath of the Great Depression and World War II. She

was still a young teacher in 1955 when Emmett Till was lynched and Rosa Parks stood her ground. She went on to witness the Vietnam War and the civil rights movement. Within her own religious circle, she and her fellow Immaculate Heart of Mary (IHM) sisters endured the wrath and persecution of Cardinal James McIntyre, the superior between them and Rome who could not stand the intellectual brilliance and freedom of these courageous activists. In 1968, she took a leave of absence and never went back to teaching. She sought dispensation of her vows. This was the year of Martin Luther King Jr.'s assassination.

To say that Corita was living in a world that felt unjust and unstable would be an understatement. She felt fear and urgency. Probably even despair at times. She wrestled with her own sense of limitation, yet did not let that define her ability to act. Her close friend, the poet, priest, and pacifist Daniel Berrigan, broke into a government building and poured homemade napalm on drafting files. He hid in the woods for several months before being sent to jail. Corita did not hide in the woods. Her way to proceed was to anchor herself in the moment, resist the appeal of apathy, and allow the changing world to change her. Being a maker under these circumstances became a necessity to create hope.

As structures and certitudes were falling apart around her, Corita was building signs pointing towards togetherness and resolution. She was learning and speaking up, borrowing words from billboards and advertisements when she did not have any. In the few days she had in between teaching duties, she produced an extraordinary amount of work. Her techniques allowed for generating work quickly: cutting, pasting, translating snapshots, slogans, or anything you would notice in the world if you did not blink. When restoring justice requires a whole new meaning for terms as basic as *god*, *peace*, or *love*, there is only make.

Much of Corita's own work, as well as her teaching, was indeed about "making" sense. It is probably why she often used the word "maker" for "artist." And yet, she did not rush her students on creating meaning. Instead, she urged them to first and foremost try new possibilities or new interlockings of images and words, to create surprises out of the ordinary, to circumvent what they thought they knew.

In theater improvisation, there is a rule requiring actors to accept anything that is sent their way and continue to build the scene with it, even when it does not match their original plan. All must belong. It can be referred to as "yes, and." Corita worked on not separating things. Art and life: yes, and! Win and fail: yes, and! There are, indeed, no mistakes when dichotomies are out the window.

Of course, much discouragement can arise when so much needs to be reconsidered, rethought, and remade. This may be why Corita taught her students many techniques to develop and trust their senses. We know now this is an effective way to regulate our emotions and be present in the moment, despite anxiety. Unease and creativity: yes, and! Through exercises of visual and auditory observation, she taught young artists to be in the world, not separate from it. When your homework is to pay attention to all you can hear—in your immediate vicinity, then far off, then as far as you possibly can—you are quickly reminded in a visceral way that the world, as unstable as it might be, is an endlessly rich source. When you are taught to observe a space (a gas station, of all places) for four hours through a little hole cut in a piece of paper, you see for yourself that anything can be a starting point. And the good news is that one can start in the middle. In the here and now. Through mundane little steps. In Corita's words, "doing and making are acts of hope." Tragedy would be to never start at all.

NOTHING IS A MISTAKE.

THERE'S NO WIN AND NO FAIL.

THERE'S ONLY MAKE.

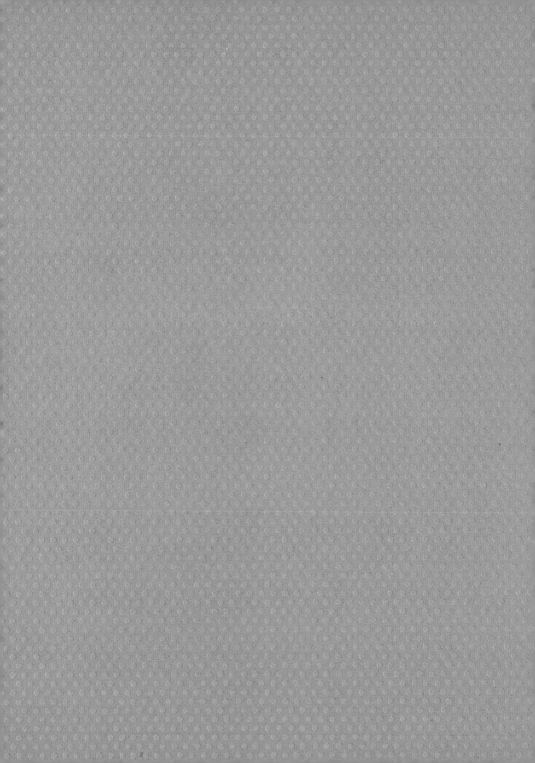

Rule 7:
The only rule is work. If you work it will lead to something. It's the people who do all of the work all the time who eventually catch on to things.

Words by Jeffrey Gibson

Art by Jen Hewett

B eing an artist is an unusual kind of work, and the "work" does not always equal labor. Being an artist allows me to cross certain behaviors in my art practice that might otherwise not be expected in everyday public life. I can spend a great deal of time thinking and looking, imagining and listening, which to an onlooker may not look like I am working, but I am always working.

I feel responsible to remain open to the unexpected, the ridiculous, and the impractical. I am committed to feeling things deeply and to being overcome with emotions that I might otherwise push away or repress. These emotions and feelings can be challenging sometimes and are like riding a roller coaster. You have to get on and ride the ups and downs until it comes to a pause and you realize you are in a different place from where you started. This commitment is work for me as an artist.

While I am on this ride I must also allow my body, mind, and hands to create and make decisions. I have to play with ideas and materials to understand them better—what they are willing to do and what they won't do. I learn a lot in this process because there is the idea or material itself and then it easily becomes a metaphor for the circumstances I am experiencing in the larger world. I have to think and make in the safe space that is my studio and with the team of people who help me realize the finished artworks.

What I have described above is the work that I do every day, whether I am in or outside of the studio. This practice has always led me to the next move, next subject, next medium, or into a collaboration with another creative mind. I am always learning, and I have come to understand the unknown as what exists just before I realize something new that enables me to move forward. This practice also changes me and propels me forward in my thoughts with new questions that I was not previously aware of.

Eventually I realize that I have something new to say that I could not have previously articulated to myself or to others, and I return to the studio to make something. A different kind of work begins, that includes imagination and experimentation, to try to reflect these new thoughts. New information

emerges during this part of the process, and I begin to edit things out that may find their way into several new artworks, including sculpture, performance, video, or installation. I always think of the finished artworks as the residue of this work, of this process, and I continue to be surprised how much "work" goes in to making a finished piece.

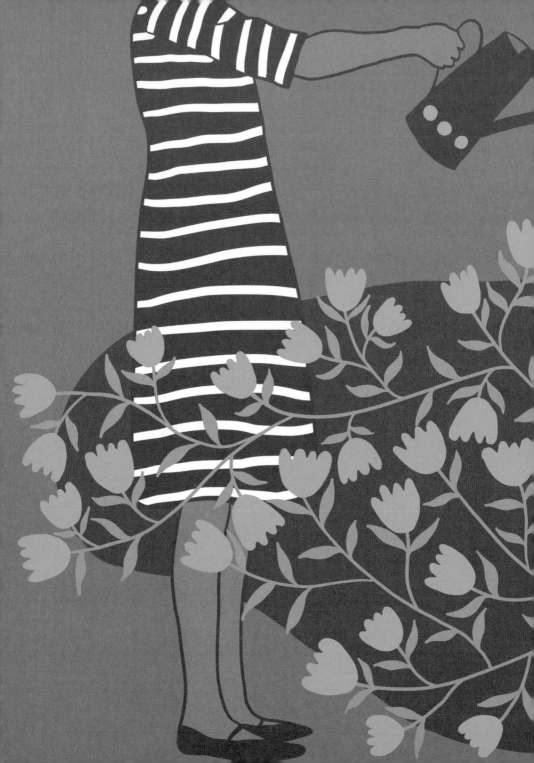

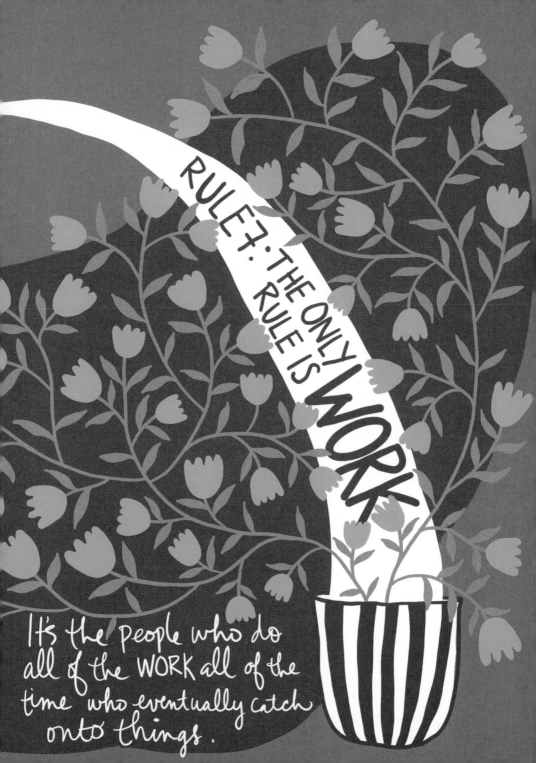

RULE 7: THE ONLY RULE IS WORK

It's the people who do all of the WORK all of the time who eventually catch onto things.

Rule 8:
Don't try to create
and analyse at the
same time.
They're different
processes.

Words by Mickey Myers

Art by Vashti Harrison

From 1962 to 1966, I was an art major at Immaculate Heart College. Our professor, Corita Kent, formerly Sister Mary Corita, had high expectations of us, her students, and was known for giving colossal homework assignments. Whatever the discipline—drawing, painting, collage—she would assign a gigantic number, instructing us to bring back fifty, one hundred, even five hundred studies to the next class, only two days later. The size of the assignments was not a rule; it was an expectation that wove through all the rules. For me, a full-time student with demanding professors in other departments, the art department rules proved an unwritten, unrelenting framework that shaped my entire undergraduate life.

The overwhelming quantity of Corita's assignments forced me to experience what it means to create—to live and work on the edge. Once I got going, there was no opportunity to evaluate what I was doing while I was doing it. I simply did the work, framed by the guidelines of her assignment. Although as Corita would say, "You are free not to do everything." Her goal was for us to bring in solutions and make connections beyond the clichés of our youthful perspectives. We took risks quickly and unceremoniously. Later, back in the safety of her classroom, we'd analyze the experience—learning from her and from each other.

The Immaculate Heart Art Department rules were written down the year after I graduated, but they were easy to recognize because I had lived every one of them. Even now, six decades later, the rules resonate in my studio with their original vitality. They were as applicable to the young student I was as they are to the senior artist I have become. Fifty-six years after graduation, the practice of quantity still gets me started in my studio every time.

In 2008 I was commissioned by the Madison Print Club, in Wisconsin, to create its 2010 print edition with a series of 140 pieces involving monoprint and pastel. I was also working full time as the director of an art center. In accepting this commission, I committed to living Rule 8 for the next two years, as time—that essential ingredient—would be tight. There would be little opportunity to do anything else in my spare moments. My social life dimmed as my creative life brightened.

The subject of the Madison commission featured a low Vermont mountain range that looked different every time I viewed it. Over years of driving

by, I never tired of its aspects, and I figured it could sustain me as a subject throughout this project (Rule 1.)

As the project's demands increased, so did the relevance of Rule 8. There would be no opportunity to analyze what I was doing, only to do it. My car became a traveling studio: I drew the view out its window on plexiglass plates with oil sticks and then returned to the press to print the plates. After hanging the prints to dry, I didn't see them again for a week.

The Madison commission was Rule 8 in action. I had to trust my instincts and my experience. Returning to examine the work a week later, I almost always found myself gratified. I didn't draw into the prints with pastel until the second year of the project. I let the work inform me of what was needed. It didn't feel like it belonged to me; it belonged to itself. I was the midwife in its process.

I had learned from Rule 8 to shed analysis and pressure and to have a plan and stick with it. Only rarely did I pass judgment on my own work in two years. That came when it was time to sign the prints and select which I would keep for myself. There was one that dazzled me so much that I still don't know how I did it. I kept nineteen others with my fingerprints on them. So much for exercising judgment.

Today, two prints in the series hang in my foyer: One is the print that I had to keep, and the other is a leftover, its fingerprints neatly hidden. The first is still wild with color and movement, vanishing in the wind. The second is soft and subtle, as a morning fog envelops the mountain, lifting slowly into the day. A decade later, I can analyze this work because I live with it, and time has added grace to what I say to myself.

The approach of Rule 8 works for me no matter what the agenda. Just getting the ideas on the table, without hesitation or fear of my own critical demons, is the first step in the creative process for me. The difference between self-criticism and learning from what one has made is vital. Self-criticism is a dead end. Informing ourselves through what we have made is an approach that can last a lifetime; the work itself provides the information. When you lay out what you have made, its analysis is provided by the dialogue that exists within the work itself.

Once I got going,
there was no
opportunity to evaluate
what I was doing
while I was doing it.
I simply did the work,
framed by the guidelines
of her assignment.

Of all the rules, Rule 8 is the only rule written in the negative; I still wonder why. Rule 8 doesn't mention the elusive nature of time, always at a premium, not to be squandered when creating. It avoids recommendations as to who, if anyone, should be analyzing your work, and it doesn't deal with creative momentum. As with so much in Corita's classroom, all those lessons would come from the work itself (Rule 7).

A dozen years after the rules were published, Corita said to me she wished she had emphasized play a little more in the rules. True to form, she was following her own principle that "There should be new rules next week." Perhaps that is the most basic lesson of all—that rules are a living document, encouraging the creative spirit in all of us to create when you create, and analyze when you analyze.

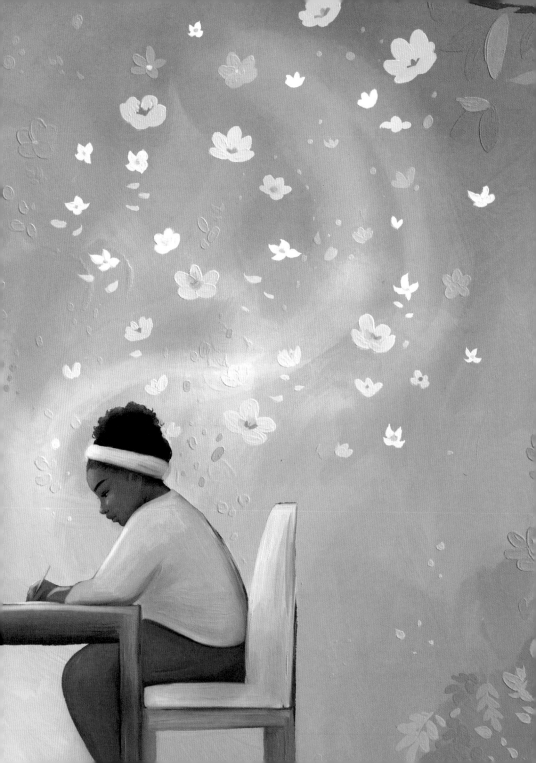

Don't try to
create and analyze
at the same time

They're different processes.

Rule 9:
Be happy whenever you can manage it. Enjoy yourself. It's lighter than you think.

Words by Karina Esperanza Yanez

Art by Rebeca Anaya

I aim to inspire students to find joy in their creative practice and learning, whatever that may look like. Today, our world puts immense pressure on artists and creatives to constantly create, post, and grind. When we aren't creating art, hustle culture forces us to continually think about creating and makes us feel inefficient when we aren't producing as much as our peers. Ahead of their time, Corita's rules create room for us to pause, reflect, be playful, and rediscover the joy of creating. The Immaculate Heart College Art Department Rules directly contradict the very nature of our fast-paced, capitalistic, tech-oriented world. These radical rules encourage us to be present.

As an artist and educator, I've been impacted by Corita Kent's work since I was introduced to her practice. My second and third years of art school were full of unpredictability. I contemplated leaving and questioned why I was pursuing art. I struggled, both socially and artistically. Navigating an immense culture shock in an unwelcoming environment made it difficult; I was at an art school and couldn't create. After I expressed my discouragement, a mentor gave me a short list of recommendations for places where they thought I might be interested in interning for the summer through the Getty Marrow Undergraduate Internship Program. Once I finished researching the list of organizations online, one place stood out: the Corita Art Center in Los Angeles. I was captivated by the colors, shapes, and messages in Corita's art.

Corita's works are playful, joyful, and simultaneously socially conscious. Her works have an energy that is not just pop art, and they are not quite what the feminist movement of the 1960s and 1970s felt like. Her art isn't exclusive or elitist, and it isn't hyper-conceptualized; Corita's art is for all of us. That summer, I immersed myself in the archives of the Corita Art Center. Downstairs, in the basement of Immaculate Heart High School, I found the joy I had almost lost. While interning at the Corita Art Center, I devoted time to scanning, documenting, and recategorizing Corita's immense archive. In those serigraphs, I found a new love for creating. My curiosity about her artistic practice grew, and her approach to art education captivated me.

Corita's unique philosophical pedagogy in art is illuminated by the documentation in the archives. Among them, one document stood out: the Immaculate Heart College Art Department Rules. These ten rules validated what I felt I was experiencing in art school. These "rules" were straightforward, playful, and open ended enough to allow room for experimentation.

For every obstacle I faced, Corita seemed to have a solution or a suggestion for overcoming it. Within these rules, something sparked for me: creating art was once again something I found pleasure in; art was approachable and welcoming.

Since then, the Immaculate Heart College Art Department Rules have lived on the walls of my studios, office, home, and every classroom where I teach. They serve as a reminder to find joy in creating, doing, and being present. What I love about the rules is that over the last decade, each time that I've reread them, I've interpreted them differently. As I have grown as an individual, Corita's impactful message has grown and adapted with me.

Rule 9, in particular, has been a helpful tool during distress and uncertainty. In a world during and in the wake of the COVID-19 pandemic, Corita's ten rules developed a whole new meaning. When the world was experiencing collective pain and trauma, Corita was there, encouraging us to find comfort, happiness, and experimentation whenever possible. Rule 9 does not always force us to be cheerful; it asks us to be happy, however that may look. It embraces the imperfections of life and obstacles it may throw at us. It does not sensationalize or romanticize the struggle of being an artist. It asks us to navigate at our own pace and comfort. Rule 9 acknowledges that creating art is not always easy. It addresses the inner complexities and duality of the occasional self-doubt artists and creatives often experience.

For me, Rule 9 encourages us to enjoy exploring our process and take pleasure in thinking and creating, knowing that the process may change tomorrow. When I think about what kind of advice I would give a younger version of myself, I reflect on what about art school often felt so difficult for me. The art world does not always welcome artists of color with open arms; it tries to pigeonhole us into binary categories that are not always healthy or accurate. I continue to appreciate that Corita made art in the only way it made sense for her and encouraged others to do the same. Corita understood that neither the art world nor managing one's own creative process is easy to navigate and that we cannot always be happy. For me, Rule 9 asks us to allow ourselves to take creative breaks, rest our minds, and enjoy those moments, even when it feels like the world often tells us this is counterintuitive. Rule 9 tells us that no matter how bad this moment may feel, we should remember: It's lighter than we think.

 BE

Happy

Whenever YOU

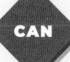 CAN MANAGE IT.

ENJOY

yourself.

It's lighter THAN

 YOU *think*

Rule 10:
"We're breaking all
of the rules. Even our
own rules. And how
do we do that?
By leaving plenty
of room for
X quantities."
—John Cage

Words by Eric Dever

Art by Carissa Potter

The Immaculate Heart College Art Department was home to rigorous learning and a commitment to community. The rules that Corita Kent brought into focus while teaching there continue to exist as condensed information, wisdom, and a living legacy.

I was first introduced to the rules in the 1970s by Mary Jane Slike, my high school art teacher, who had been an art student and Corita Kent's art department aid from 1952 to 1956. Corita and the art department's legacy were already well established beyond the college by graduating students, artists, and teachers alike who embraced new ways of learning and the rules. Corita's own pop art serigraphs were being increasingly circulated and exhibited, entering academic and museum collections as Corita and her fellow teachers travelled across the United States to New York and on to Europe, bringing back treasures and experiences to the college, published in their much-anticipated *Irregular Bulletins*.

At the time, I received the rules with the same reverence with which they were presented, and carefully considered each one—what did they mean to me? As a student who sought to learn everything I could from exceptional teachers, I appreciated the invitation to participate and trusted this education, which ultimately led me to embrace my own vocation as a painter and visual artist. Over the years, the rules have continued to reveal themselves, resonating more deeply as I, now a mature artist myself, approach the full measure of Corita's wisdom.

Corita collaborated with and quoted many artists. My personal favorites include poets, writers, and playwrights such as Joseph Pintauro, Daniel Berrigan, and e.e. cummings. Today, it comes as no surprise to me that Corita highlights John Cage in the final rule: "We're breaking all of the rules. Even our own rules. And how do we do that? By leaving plenty of room for X quantities." —John Cage.

Corita and John Cage (who studied Indian philosophy and Zen Buddhism) both understood and embraced the inevitability of chance and change in their work and lives. *I Ching*, a Chinese text that uses chance in decision-making, became an important tool in Cage's musical compositions.

Some might interpret the rules as a manifesto, but Rule 10 eliminates any possibility of dogma: "We're breaking all of the rules. Even our own rules." There is an extraordinary fearlessness expressed in Rule 10, which is appealing and characterizes both youthful and sage wisdom. How many of today's problems could be averted by such awareness?

On a practical level, as working artists we need to acknowledge the X quantities and trust how they enhance our experience. Sometimes change is uncomfortable, or even scary, but it is necessary to evolve or grow into our potential. Scraping down an area of a painting despite an attachment to it or an investment in time, glazing or painting over an area, working back and forth with layers again and again, and creating and analyzing later (Rule 8) are how some achieve breakthroughs that unveil new meaning.

Where do we find these X quantities? Some artists prefer formal limitations, choosing a limited palette over a selection of every commercially available prepared hue. We can also broaden our experience by working against our tendencies, taking a different approach in an opposite direction. The ability to mine our everyday environments for subject matter was clearly demonstrated by Corita through her use of viewfinders. These are cut-out cards, which served as cropping devices, uncovering unexpected compositions in advertisements, magazines, and commercial signage in nearby communities.

The X quantities also result from experiments and a commitment to the work (see Rules 4 and 7). My personal trajectory as an artist might be best described as moving from one X quantity to another, resulting in a long equation or conversation with myself and others. From 2006 to 2010, I limited my palette to zinc and titanium white as a means of exploring the methods and materials of painting. This enabled me to uncover a white spectrum ranging from opacity to translucency, unexpectedly developing a heightened sensitivity to the properties of the linen, canvas, and burlap that provided both surface and support in the work. The introduction of black to my work, in 2010, was another X quantity, which widened the range and force of the work. My new compositions were largely geometric, including grayscales and circles graded from dark to light. I gradually added red to my palette, thanks to contemporaneous yoga studies and an inward journey exploring the qualities of light energy and matter, principles discussed in Patanjali's *Yoga*

Sutras and the *Bhagavad Gita*. I began testing prepared red hues, and by 2012 had arrived at naphthol scarlet, a modern replacement for vermilion. Relative color theory, as discussed by Josef Albers, emerged in new paintings examining similar values of opposite tones.

Sometimes the worst experiences can be met as challenges or opportunities that drive us toward self-examination and real change. Nature, beginning with our own bodies, is in a constant state of flux and seasonality. Illness and loss brought me closer to mortality, and a rapid succession of X quantities followed, including working with the full color spectrum, gesture, and the natural world. After all, time and tide wait for no one. Art remains an expression of our own humanity and provides us with important release and learning.

The rules themselves remain a personal touchstone for me. Leaving room for X quantities (Rule 10) might even include leaving space for happiness and enjoyment (Rule 9), which is especially important for "the people who do all of the work all the time"(Rule 7). Looking through the lens of time and experience, I feel as though the complexity of the rules is also a window into Corita's world as an artist and teacher, beginning with her name. Sister Mary Corita became Corita Kent, with whole new sequences of X quantities to be discovered in secular life, moving from Los Angeles to Boston, painting and learning.

Helpful Hints:

Always be around.
Come or go to everything.
Always go to classes.
Read anything you can
get your hands on. Look
at movies carefully, often.
Save everything—it might
come in handy later.

There should be
new rules next week.

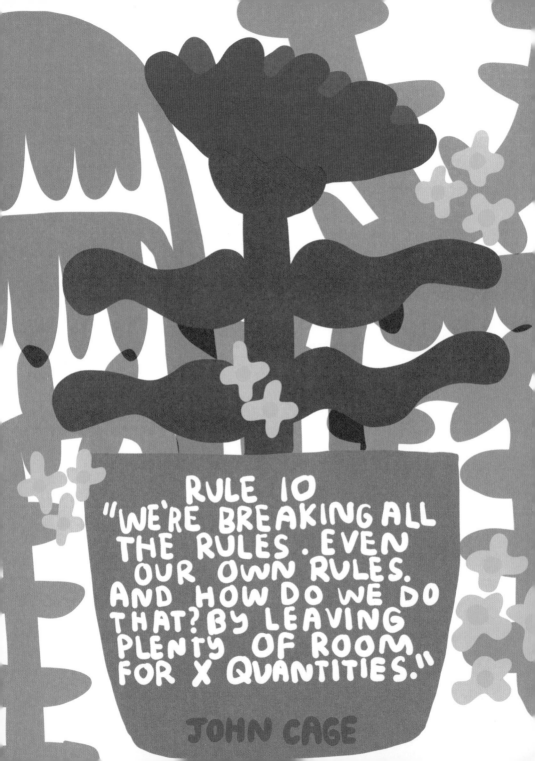

RULE 10
"WE'RE BREAKING ALL
THE RULES. EVEN
OUR OWN RULES.
AND HOW DO WE DO
THAT? BY LEAVING
PLENTY OF ROOM
FOR X QUANTITIES."

JOHN CAGE

HELPFUL HINTS:
ALWAYS BE AROUND.
COME OR GO TO EVERYTHING.
ALWAYS GO TO CLASSES.
READ ANYTHING YOU CAN
GET YOUR HANDS ON. LOOK
AT MOVIES CAREFULLY,
OFTEN. SAVE EVERYTHING—
IT MIGHT COME IN HANDY
LATER. THERE SHOULD BE
NEW RULES NEXT WEEK.

About the Contributors

The Writers

Juliette Bellocq is a graphic designer. Through her studio, Handbuilt, she collaborates with space-makers, educators, designers, and artists to provoke civic and cultural experiences.

Eric Dever is an American painter who has exhibited throughout the United States and abroad since the early 1990s. His paintings are held in the collections of the Grey Art Gallery at New York University; Parrish Art Museum, New York; and Guild Hall Museum, New York.

Lenore N. Dowling, IMH, is a member of the Immaculate Heart Community and a former colleague of Corita Kent's at the Immaculate Heart College Art Department, where she taught film classes.

Jeffrey Gibson is a painter living in Brooklyn, New York.

Haven Lin-Kirk is an artist and award-winning designer, as well as dean and faculty member at USC Roski School of Art and Design.

Barbara Loste, PhD, based in Portland, Oregon, is a retired curator, arts manager, and educator who studied art with Corita Kent in the late 1960s.

Mickey Myers studied with Corita Kent at Immaculate Heart College from 1962 to 1966. She is an artist and an arts administrator living in Vermont. Corita appointed Myers as the artistic advisor to her estate. Currently she is writing a memoir about her time with Corita.

Dan Paley is an author whose books include an upcoming picture-book biography of Corita Kent.

Natacha Ramsay-Levi is a fashion designer and artistic director living and working in Paris. In 2021, as the creative director of Chloé, she designed a collection in conversation with the works of Corita Kent.

Karina Esperanza Yanez is a visual art and social science educator from South Central Los Angeles with a history of working in arts education and arts management. Her goal is to provide students with the necessary tools to become creative in their own right as young artists and positively engage with their communities.

The Artists

Rebeca Anaya is an art director and designer focused on lettering, type-inspired branding, and editorial design, based in Mexico.

Gail Anderson is Chair of BFA Design and BFA Advertising at the School of Visual Arts and creative director at Visual Arts Press. Anderson serves on the Citizens' Stamp Advisory Committee for the US Postal Service and the advisory boards of Poster House and The One Club for Creativity. She is an AIGA Medalist, the 2018 recipient of the Cooper Hewitt, Smithsonian National Design Award for Lifetime Achievement, and a 2022 Art Directors Club Manship Medallion honoree. Her work is represented in the Library of Congress permanent collection, the Milton Glaser Design Archives, and the National Museum of African American History and Culture.

Lisa Congdon is a Portland, Oregon–based fine artist, illustrator, and author known internationally for her colorful drawings and hand lettering. Her playful work is recognized for its vibrant palettes, geometric patterns, and uplifting messages.

Vashti Harrison is an artist, author, illustrator, and filmmaker. She is passionate about crafting beautiful stories in both the film and children's literature worlds.

Jen Hewett is a printmaker, surface designer, and textile artist based in New York's Hudson Valley. Her work combines her love of loud prints, 1970s maximalism, and saturated colors with the textures and light of the landscapes that surround her.

Howsem Huang is a graphic designer, photographer, and multidisciplinary artist based in Vancouver, Canada. Huang holds BFA degrees in graphic design and photography from California College of the Arts. He has lived in Canton (Guangzhou), San Francisco, and Vancouver.

Erin Jang is a designer and illustrator living in New York City. Play, color, and craft are consistent across her work, along with a graphic style and editorial approach.

Amos Paul Kennedy Jr. is a letterpress printer and the founder of Kennedy Prints! He lives in Detroit.

MacFadden & Thorpe is a small multidisciplinary studio based in San Francisco with an interest in typography as expression. Their contribution was designed by Karoline Hatch.

Carissa Potter's prints and small-scale objects reflect her hopeless roman-ticism through their investigations into public and private intimacy. She is the founder of People I've Loved and is based in Oakland, California.

Acknowledgments

Corita Art Center dedicates this book to educators everywhere.

A special thank you to the late calligrapher David Mekelburg, whose lettering of the Rules is widely beloved and graces the cover of this book. To the incredible filmmaker Baylis Glascock, who thoughtfully captured the making of the ten rules in his 1967 documentary *We Have No Art*. To the Immaculate Heart Community, who remain steadfast in upholding Corita's legacy and ethos. Thank you also to the John Cage Estate and to John Cage, without whom there would be no Rule 10. Lastly, our eternal gratitude goes to all of the Immaculate Heart College Art Department students.